Claywork

Claywork

Form and Idea in Ceramic Design

Third Edition

A GUIDE FOR TEACHERS

Leon I. Nigrosh

Davis Publications, Inc.

Worcester, Massachusetts

Acknowledgments

I would like to thank Sheila Tetler, art teacher at the West Boylston, Massachusetts, Junior-Senior High School, for her valuable assistance in the preparation of this guidebook. Thanks also to Richard Shilale, art teacher at Holy Name Central Catholic High School of Worcester, Massachusetts, and Kaye Passmore, art teacher at Notre Dame Academy, Worcester, for allowing me to spend time in their respective classrooms.

Copyright 1995
Davis Publications, Inc.
Worcester, Massachusetts

Printed in the United States of America
ISBN: 0-87192-286-X

10 9 8 7 6 5 4 3 2 1

Contents

Claywork

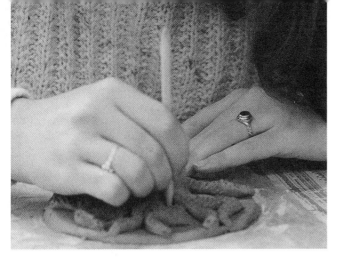

Introduction

Earth. Air. Fire. Water. The ancient elements of all things earthly. These are also the essential elements of claywork. Combine earth and water, subject the mixture to air and fire, and the resulting object is of great permanency.

From the earliest recollections of mankind, humans have had an affinity for clay. Toddlers love to stomp around in mud puddles. Even as adults we still enjoy squishing barefoot through the beach mud at low tide. Something within the human psyche keeps bringing us back to clay. Biblical readings suggest that we human beings were made from the dust of the earth — clay.

The Magic of Clay

In days gone by, the magical powers of clay were often invoked by shamans and priests alike. Predynastic Egyptians relied upon tiny clay figures to ensure the healthy birth of their children. South American cultures made portrait urns of their leaders to commemorate their reign and secure them a peaceful transition to the afterlife.

Even today, some people still believe in the curative powers of clay. Thousands of people half-jokingly slather their bodies with sulfurous mud on the shores of the Dead Sea in Israel in hopes of curing arthritis and other ailments. Others spend large sums of money to preserve their health by being immersed in mud baths at prestigious spas.

Clay History

What little we know about ancient civilizations is often based on the few shards of baked clay that have survived the ravages of time and been unearthed at archaeological digs.

Many cultures such as Japan, China, India and Korea have rich pottery traditions that are still active today. The first Europeans to come to this continent were too busy trying to find food and shelter to devote much time to continuing their ceramic traditions. However, the indigenous people had long before developed a wide array of pottery styles that are still handed down from mother to daughter today.

Creativity

The urge to create is within us all. It is particularly prevalent in younger people — those who are still forming their ideas about the nature of life. Some express their creativity through sports or music, others turn toward art. Drawing and painting can often mollify this urge to be creative, but they must rely on artifice to give the illusion of three dimensions. Admiring a freestanding object of one's own design is a truly satisfying moment.

Many media are available to construct three-dimensional works of art — among them are metal, stone and wood. However, both inside and

outside of the classroom, clay is the most easily manipulated creative medium. It is abundantly available, and it requires little more than our own fingers to mold whatever images may come to mind.

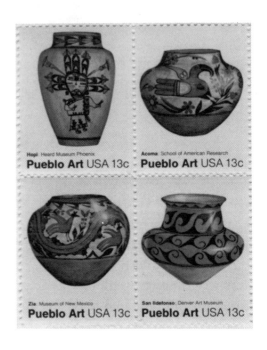

This block of U.S. commerative stamps, issued April 13, 1977 in Santa Fe, New Mexico, portrays four examples of Pueblo Indian pottery from the Zia, San Ildefonso, Hopi and Acoma Pueblos, ca. 1880-1920.

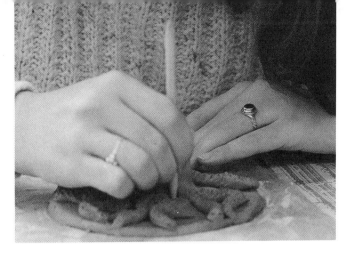

About this Book

This third edition of *Claywork* has been written with both teacher and student in mind. The chapters have been set up in sequence from simple methods to more complex techniques. Within each chapter, the same logical arrangement is used, with suggested projects ranging from the easiest to the more involved.

For greater ease of understanding, all the methods are illustrated with photographs taken from the reader's point of view. As an example, in chapter five the written information about how to pull a handle for a pitcher is illustrated with the photo series on pages 91–92. These pictures show the proper positioning of each hand to successfully execute this maneuver.

Elements of Design

Unique to this textbook is the chapter on Design in Clay. Eleven principles of design are discussed, with specific reference to ceramics. Each principle is illustrated by one or more examples of contemporary claywork.

Spotlights

New to this third edition of *Claywork*, Spotlights provide historical and contemporary information about clay-related processes and the people who use them. Your students will find these asides informative, thought-provoking and relevant to the content covered in the chapter.

Vocabulary and Terminology

Throughout the text, words related to specific ceramic materials, activities, equipment, styles and techniques are highlighted either in italics or boldface type. Explanations follow immediately. The "Dictionary of Ceramic Terms" found on pages 243–248 contains concise definitions of just about every word associated with the ceramic arts. Appendix A, Ceramic Raw Materials, pages 252–258, defines all the chemicals and compounds common to the ceramic field and describes their uses as well as necessary precautions.

Armed with these references, virtually any vocabulary question can be easily answered and understood.

Health and Safety in the Classroom

Increased concern about possible health and safety hazards have caused the premature demise of a number of school ceramic programs. In many cases alarm would have been unwarranted had the conditions been properly evaluated and certain simple precautions taken. To assist you with such situations, the author notes possible circumstances in the appropriate sections of the text

and then offers solutions. This information is highlighted throughout the text in **boldface.**

For example, in chapter nine, Glazes, the author lists seven specific precautions to be followed for safety while handling materials.

Appendix A discusses the properties of raw materials appropriate for ceramics. While this is primarily written for those who are involved with glaze formulation, it is well worth reading just to gain an understanding of the compounds used in the making of clay objects. Each description explains the characteristics of the material in its various forms, and suggests possible uses.

More importantly for general classroom use, health hazards are noted for each material in bold face. Also in this appendix is "A Note About Lead" which explains the potential hazards of this material along with methods of reducing or eliminating the problems.

Ceramic materials manufacturers and suppliers have become much more involved in the past decade with the questions of health and safety. Several no longer stock extremely toxic materials. Most now provide more descriptive information about their products and label those materials which might create risks if mishandled. Two excellent health and safety guidebooks specifically related to ceramics are available:

Barazani, Gail, *Ceramics Health Hazards: Occupational Safety and Health for Artists and Craftsmen.* Boscobel, WI: Art-Safe, Inc. 1984.

Seeger, Nancy, *A Ceramist's Guide to the Safe Use of Materials.* Chicago: The Art Institute of Chicago. 1982.

"I enjoy working with clay because I can use my imagination and create almost anything."
Erin Murphy

A good way to make your class more aware of safety would be to have them develop their own Safety Check List. Using the information in the text, have your class check such things as proper labels on containers and adequate ventilation for kilns and spray areas. Make sure there are rubber gloves, masks, aprons and goggles in the glaze area. Discuss and note problems about eating in the work area, proper storage of materials, care of equipment and personal cleanliness. After the classroom has been checked and any potential problems corrected, have the students make a poster or series of posters stressing proper safety rules and attitudes.

The Studio

Every clay art teacher dreams of the ideal studio filled with wheels, kilns and the best tools and supplies that are available. For those of us with modest budgets, the information contained in chapter eleven, Kilns, Wheels and Studio Equipment, can be of great value.

The "Studio Equipment" section is a succinct list of important information necessary to maintain a clean and efficient clay class operation.

Note particularly the suggestions regarding shelving and plumbing. To prevent all manner of minor incidents and confusion, set aside separate shelving for works in progress, clay forms that are

dry and awaiting firing, bisqued pieces to be glazed and fired ware. Glazes and glaze materials need to be stored safely, but within easy reach.

Clogged plumbing can be avoided with a few simple precautions. Industrial-type sink traps are easy to install and maintain. Trapped waste should be properly discarded. If sink traps are not available, simply have students wash clay-covered tools and hands in a bucket before using the sink. Periodically this bucket should be drained and dried. If it is a clay-only bucket, the resulting scrap can be reused. Use other buckets for washing glaze utensils, the dried contents of which should be discarded. Have separate buckets for any scrap plaster.

Cleanliness

Keep your art room/studio well stocked with sponges. Leave time at the end of each session for students to wash down all working surfaces. Use large squares of canvas or old window shades to cover desk tops. Newspaper will only shred and contaminate the clay. One classroom teacher has students cover work tables with large blue tarps. At the end of each work session, the tarps are simply rolled up and stored until the next class period.

Using This Text in Your Art Program

Art programs often differ from community to community and even from school to school. This book is organized in a logical format as a basic teaching tool for both beginning and advanced students, and as an active reference for professional clayworkers.

To use this volume most effectively, first review all the material to see how it relates to your

A Sample Study Plan

An important aspect of this book is that although the chapters present ceramic techniques in increasing order of complexity, each chapter can be used alone. For example, if your class is going to focus on coil building, students can simply turn to chapter three, Coil Building, to learn how to roll and join coils.

Examples of historical and contemporary works show many different ways coils can be used to build imaginative objects. Suggestions are offered for ways to develop individual forms. Finally, more advanced methods of coil building are discussed.

After making several items with the coil technique, it might be advisable to turn to chapter seven, Traditional Decorating Techniques, to experiment with different ways to decorate these pieces before they have hardened.

particular course, the interests and abilities of your students and your own style of teaching. Then arrange an outline of how you plan to incorporate these elements into your class structure.

Upon completing a simple outline, note ways to augment the text by planning to introduce actual examples of ceramic works made in a particular technique, or by showing slides of historical and contemporary pieces.

Arrange field trips to visit a local museum. Most municipal museums have historical pottery on permanent display along with occasional exhibitions that might be appropriate. Several major museums throughout the country have extensive collections of ceramics well worth seeing many times. Art galleries in your area often have chang-

ing exhibitions that feature contemporary ceramics. Ask to be placed on their mailing lists so that you will be aware of these shows. Talk to the directors to see if your class could visit as a group. Otherwise, advise your students of the show and suggest that they go on their own time.

Demonstrate

Plan time to demonstrate each technique. (If you are not particularly adept at a specific method, there are several good films and videotapes available for classroom use.) Better yet, invite a local artist to visit your class to give the demonstration. At that time, perhaps the artist could also discuss what it is like to be a professional clayworker. A follow-up field trip to the artist's studio could be a highlight of the course.

While demonstrating a particular technique, try to alert students to any inherent pitfalls. However, resist the temptation to show your class "the right way" to do things. Creativity comes from experimentation. Students need the leeway to figure out things for themselves. Keep your hands off their work.

Special Needs Students

Demonstrations are particularly important for students with special needs. Often showing the actual movements required to complete a particular operation is a more effective teaching tool than a simple discussion.

Step-by-step drawings or photos of a particular clay-forming technique, such as those shown throughout *Claywork*, posted on the walls can serve as reminders for students with attention problems.

Ask the English as a Second Language teacher or a parent to translate pertinent information in writing for students who do not yet speak English.

Most importantly, have realistic expectations regarding student capabilities. Given the chance, they *can* achieve.

Interdisciplinary Activities

Many art teachers have developed programs in conjunction with history, language and science teachers that serve to make students aware that life does not consist of a series of little boxes, but is rather a vast continuum of interlaced activities. If such a program has not yet been incorporated into your school curriculum, you can at least make it an exciting part of your own course plans.

As an example, before simply having students make their own ceramic tile mosaics, one art teacher directed students to examine the Byzantine era, with all of its political and social ramifications. The class then took a field trip to the local museum to see several remarkable Greco-Roman tile walls firsthand. Only after discussing what they had studied and seen were the students given the opportunity to design and create their own artworks.

Developing Awareness

One major obstacle that faces almost all students is the inability to "see around corners;" that is, to be able to imagine the other side of a three-dimensional object while viewing it. In order to acquire this aptitude, students need the opportunity to actually make well-designed works of their own. One material that is highly suitable for this endeavor is clay.

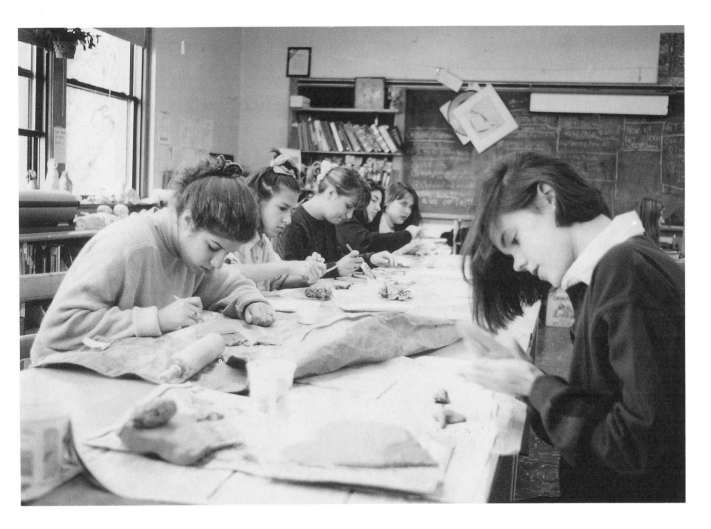

These students recently completed a short study of ancient Greek and Roman art and architecture. Each one was then asked to research a Greek or Roman myth of their choice and write a report about it. They are shown working on clay bas-reliefs of their own design which portray the particular myth they chose.

The malleable properties of clay will allow your students to make changes easily in their designs without altering permanently or destroying the work in progress. As your students become more adept at handling clay, the process will become so natural that they will begin to develop viable forms with ease. Soon they will be able to truly "see around corners."

To demonstrate this point, show a ball to your class. Have them discuss how, by just looking at one view, they "know" the ball is round. Then display a sculptured work and ask the class to describe the other sides without turning it. Discuss how the effects of light and shadow provide clues about the shape of the object.

Another possibility would be to place an unknown object in a bag and have students identify it by placing their hands in the bag and just touching it. Have them describe the textures, curves, holes, weight and other pertinent information.

Teacher Self-Evaluation

Although art teachers need to focus on their students' progress, every so often we should take time to look at how we are doing ourselves. Are we getting our point across in class? Does student work show continuing signs of improvement and creativity? Are we still having fun?

Read up on the latest material and equipment advances in the field. If possible, observe other teachers at work to see how they motivate a class. Attend conferences to meet and empathize with colleagues from other schools, states or countries. Take the occasional workshop to sharpen your own skills.

Using this Book

1 Clay

This chapter discusses the natural formation of clay, the different types of clays that can be found in the Earth's crust and how to test and prepare them for use.

Practical Issues

The ideal teaching sequence would be for students to discover and mine their own clays from mountainsides, ponds or quarries. Students would then perform all the tests discussed in this chapter and prepare their own clay.

More often, the clay in the classroom comes out of a bag. Clay bodies formulated from natural clays and materials are best because they store well and can be recycled. Clays that can be fired offer the widest range of finishing techniques. The finished results are permanent.

The qualities of most self-hardening clays are almost completely the opposite. They do not have a long shelf life, finishing techniques are limited and they are virtually impossible to recycle.

Depending upon the scope of your course, students can still learn to perform the various tests on the commercial clay to discover its properties. If time does not allow for this activity, at least discuss the differing properties of a number of clays

so that your students will have a better understanding of the material they are using.

Remember: Use a wire or nylon fishline to cut clay from the bag.

2 Pinch

Pinch forming is the easiest way to get students into clay, literally. It is the most basic of techniques, requiring only some clay and some fingers.

Follow the picture sequences to get students started.

Several variations on basic pinch forming are suggested throughout the chapter. Have students try each one, then let their creativity take over. See what kinds of forms they can develop on their own.

3 Coil Building

Tools

The introduction of a few simple hand tools is all that is really necessary to work with coils: wooden modeling tools (tongue depressors or popsicle sticks will do the trick), some sort of serrated edge to roughen the coils (segments of a

saw blade, for example) and squares of plywood or small plaster bats on which to place the work. A little vinegar will help join stiffened coils. Bench wheels are great optional equipment.

Remember to wrap unfinished projects in plastic so that they will not dry out too soon.

Building with Coils

The thrust of this chapter is to get students thinking about qualities inherent in the coil-building technique itself. Rather than spend an inordinate amount of time attempting to construct symmetrical objects, encourage students to work with asymmetry and the organic aspects of coil building.

Require sketches in advance so that both you and your students will have an idea of what they intend to try building.

To emphasize the organic qualities of coil building, one classroom project could be to have students bring in various fruits and vegetables. Then have students attempt to render exact duplicates in clay or create enlarged versions.

Historically many cultures brought this process to such a high art that viewers were often hard put to discern which was real and which was made of clay. Pictorial examples of pre-Columbian, Chinese and English works can easily be found in many art history books.

4 Slab Construction

Tools

In addition to the few tools needed for coil building you will need: rolling pins; wooden slats; canvas, burlap or other textured fabrics; measuring sticks; potters' knives or other slightly dull metal knives for cutting the rolled slabs; brown paper and light cardboard for pattern making.

Slab Building

Slab building offers students an opportunity to develop architecturally oriented objects. Sharp edges and rectilinear forms are best produced with this method.

A beginning project might be the production of several 6 x 6 inch slab tiles, each with a different surface texture, as explained on page 61. Various textural ideas can be taken from examples shown in chapter seven, in the sections on plastic, leather-hard and dry applications.

The tiles might be considered as hot plate/trivet designs, imaginative clock faces or bas-relief scenes.

Sketching the images for the tiles beforehand helps students focus on the project. Require sketches of proposed three-dimensional freestanding works as well.

5 Throwing

Tools

Elephant ear sponges, cut-off wires, wooden knives and pin tools are the basic necessities for wheel throwing, aside from a decent potter's wheel. Other tools that can make the throwing process easier are leather strips for finishing; pot lifters; assorted sharp-edged trimming tools; thick dowels for bowl and plate making; throwing sticks or sponges-on-a-stick for making bottles;

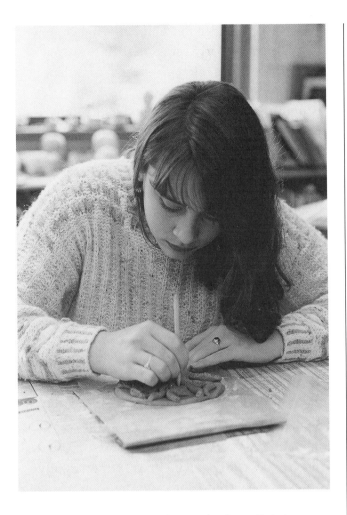

Student Elizabeth Riccio working on her bas-relief of Medusa. "I like working with clay because it's fun. It also helps me forget about my problems."

calipers for measuring covers and assorted metal, wooden or rubber throwing ribs for perfecting forms while throwing.

Throwing

Many art teachers resist presenting this method of clayworking because of a genuine fear that they personally are not competent enough to carry it off in front of a roomful of students. It takes many hours of concentrated practice and continued application to master the wheel, but rudimentary capabilities are all that is necessary to show students how to get started.

To introduce students to the art of wheel throwing, bring in examples of thrown pieces, show slides and have a discussion about just what it is that has made this method so popular worldwide for centuries. Get the students excited about the idea of making pots on the wheel (this is not usually too difficult to do). Do caution them that while throwing is not as easy as it may look, it is not as difficult as one might imagine.

The next step is an assigned reading of only the first two pages and the accompanying photos of chapter five on Throwing. This chapter has been divided into many simple steps, and each, when correctly followed, leads to the next step.

It is important to stress that skipping or skimping on a particular portion of the activity can make the next move impossible to adequately perform.

Have each member of the class ready clay according to the instructions given under the heading "The First Steps." Discuss the other information in this section to be sure they understand how to properly prepare *themselves*.

Next, have each student practice *centering* and *forming* a cone, as discussed in these two sections. Before any other moves can be made, it is essential that these operations be perfected as nearly as possible. When the students have learned to center, then, and only then, let them work on *opening a hole*.

Once your class can properly prepare clay, center a ball of it and open a hole without knocking the piece off center, proceed to the section, "Making a Cylinder." A cylinder is the basic form for all objects made on the wheel. A bottle is just a cylinder with a squeezed top. A plate is simply a low, wide cylinder. If a student can throw a cylinder, he or she can learn to make just about anything else. All that is necessary to achieve this, is to follow the directions, look at the photos and practice.

Practice is the key word. Make sure that enough time is available to students, in or out of class (if possible), for them to work on improving their skills.

Continue slowly through the Throwing chapter, allowing the class time to learn about removing a cylinder and trimming. Repeat as much of the instruction as needed, until each pupil can complete several reasonably cylindrical forms.

At this point it might be worthwhile to look into decorating these simple objects. Assign readings in chapter seven, Traditional Decorating Techniques, which can be used when the clay is still plastic, or wet. Have the class experiment with decorations on both leather-hard and dry pieces. Fire these works, with or without glaze. It is always a good idea to let students finish some work during the early stages of their throwing development. This often gives them confidence to pursue more involved shapes.

Continue to work with the text in the same manner for other sections. Before making pitchers, show examples, discuss whether pitchers are even necessary, talk about historical forms, discuss optimal weights.

When students begin to independently develop forms on the wheel, discussion about form and design can be brought in through readings in chapter six, Design in Clay.

> *"I love the way a formless blob of clay can become a beautiful pot or vase or sculpture."*
> Nicole Nicas

6 Design in Clay

This chapter introduces eleven principles of design that can be applied to just about every artistic endeavor in any medium. For our study purposes, the explanations and the accompanying images are all clay related.

Material in this chapter can be called upon early in any ceramic program. Use this information as the basis for classroom discussion of student work as soon as the first pinch forms have been completed.

For example, one principle states that "Tactile quality is part of the experience of a work." The section then talks about the fact that people like to touch ceramic works and enjoy using them to enhance the pleasure of eating and drinking. The use of highly textured areas played against

smooth portions makes sculptured works more exciting as well.

Encourage your students to experiment with the textures that naturally occur in their own work and to resist the temptation to "smooth out" everything.

The author also suggests exploration in other areas of design, art and nature for influential ideas. Have students bring in examples of automobile, architectural and fashion designs that appeal to them. Discuss which principles of design are evident in these examples and how they might be incorporated into their own work.

Several basic thoughts about attitudes toward claywork are also included to stimulate class discussion. The current wave of contemporary ceramic design seems to be moving away from the simple utilitarian forms that have been in use for centuries. Using exhibition catalogs, slides or magazine photos, have your students analyze modern works to see if they withstand the scrutiny of the principles of design as set forth in the text.

Evaluation Tips

Younger students can draw upon the information contained in this chapter to fill in Self-Evaluation sheets. Have students set goals for each individual project and write them on this sheet. After the project is completed, ask the students to assess their work: How close to the original idea did they come? What problems did they encounter? What improvements could they make, if any? How does their work relate to the design principles discussed?

By having students evaluate their own work in this nonthreatening manner, they will soon become more confident and willing to discuss their work openly.

Older, more self-confident students can use the design principles as the basis for classroom discussions or critiques, wherein they talk about their own work and the work of their classmates. Teacher input can be held to a minimum, keeping the direction of the critique to a narrow focus. This will allow a freer exchange of ideas among the students while still fulfilling the requirements of the particular project.

7 Traditional Decorating Techniques

Virtually every tried-and-true method for decorating clay is covered in this chapter. Ideas and examples of decorations done when the clay is still plastic, leather-hard, dry and bisque fired are shown along with appropriate tools.

The all important methods of applying glaze are explained and illustrated: pouring, dipping, brushing and spraying. The advantages and drawbacks of each method are also noted.

Colored Clays

Colored clays can be successfully used with pinch, coil, slab and even throwing techniques, provided that the few simple suggestions in the text are followed.

Underglaze

Depending upon classroom conditions and supply budget, this particular technique can be used either to augment a program that

Grade it yourself instead of the inspector general.

Put a star on the line where your project rates:

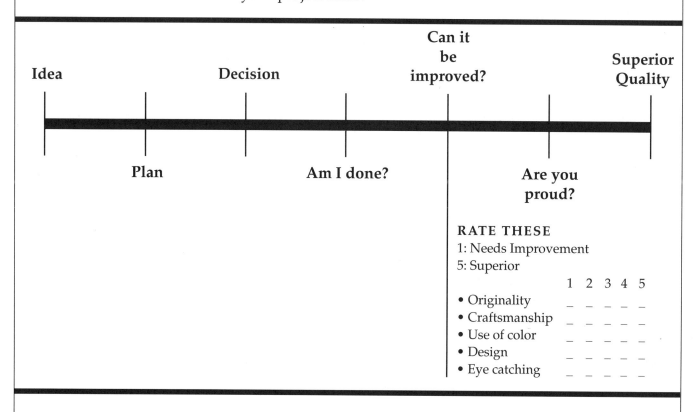

Briefly, on the back, describe your work, analyze it, and tell what happened as you made it.

Mark the line where your project rates.

Name of project _____

Your name _____ Slot # _____

Your letter grade _____

incorporates glazing or as a satisfactory alternative.

One of the most common problems voiced regarding clay programs is the extensive cost and waste of commercial glazes in the classroom.

Underglazes are available in a myriad of colors. They are easily applied, can be color mixed much like paints, are easily reconstituted if they dry out in the jar and rarely burn out when fired.

In a classroom situation, underglazes are best applied after clay objects have been bisque fired. After all the colors have been applied, two or three smooth coats of a clear glaze are all that is necessary to bring out bright colors after firing.

Test Tiles

To reduce confusion about what the manufacturer's imaginative names really mean, have fired tiles of each glaze and underglaze clearly labeled and displayed for students to see BEFORE they start decorating their work.

8 Adapting Commercial Decorating Techniques

The information contained in this chapter is primarily for advanced students involved in extensive ceramic programs. Specialized equipment is often required to achieve particular effects.

This should not preclude discussion of and possible experimentation with any of the techniques, if resources and time allow.

The Acrylic Lift method of mounting newspaper or magazine pictures onto fired clay objects

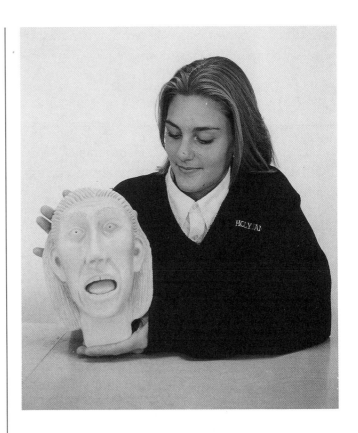

Senior Jill Ermanski shows her Self-Portrait in Shock. "I chose clay to do my self portrait because it is easy to work with and very forgiving. I enjoy the clay because of its freeness to be molded into any shape. I also like the fact that the finished work is three-dimensional."

(described on page 158) is one technique that can be easily adapted for classroom use.

9 Glazes

This chapter is also designed for students involved in an extensive ceramic program. Access to a full array of ceramic raw materials is necessary to take full advantage of the materials explained.

Materials Handling

This short, but important section (mentioned earlier under "Health and Safety in the Classroom") should be studied by anyone working with glaze materials.

Glaze Formulation

Few clayworkers ever feel really satisfied until they have developed their own glaze formulas. However, the task seems formidable to many students and teachers alike. This text helps to take the mystery out of glaze formulation. To simplify understanding, all chemical formulas are separated into their essential oxide relationships instead of the more complex chemists' notations. Only those compounds directly related to ceramics are included.

Fusion Buttons

The chapter begins with an explanation of fusion button testing. This is a simple mix-and-fire method that produces physical results for examination, and allows students to actually see how a glaze is formed.

To prepare for this exercise, have your students make a number of small square slabs with a depression in the center of each and bisque them. Fill a melon scoop with the materials to be tested and carefully invert the scoop onto labeled tiles. Fire the samples to the desired temperature. After the firing, examine the samples. Those samples that appear as smaller glassy domes are suitable for use at that temperature. The next step would be to dry-mix two or three compounds together, make new fusion buttons, and fire them. If the results are powdery or have completely melted, remix the materials in different percentages and try again. Keep careful notes of the amounts and materials used. When a reasonable sample has been produced, mix a larger amount and fire it on a small test pot to see if it is indeed a workable glaze.

Glaze Development

Theoretical calculations are laid out in a chart that easily shows the necessary oxide relationships for any formula. Again, the chapter proceeds in a step-by-step fashion, with basic explanations. To enhance student understanding, at the end of each section appropriate problems are given (with the answers in the back of the book). Based on each section, you may also want to construct additional problems for the class.

In conjunction with this chapter, students should become familiar with three appendixes. Appendix A contains the most complete and succinct explanation of all raw materials related to ceramics.

Appendix C lists the formulas and weights of those materials as well as certain feldspars and

frits. The information in these two appendixes is needed to help formulate viable glazes.

Appendix B lists the atomic weights of common elements and oxides, for students who want to know how to calculate the raw material formulas.

Student Glaze Development

After your students have worked with the appendixes and successfully completed the problems in this chapter, have each student formulate his or her own glaze. These glazes should be developed for firing at your usual cone temperature.

First, have students decide what qualities they would like to have in their glazes. Based on this, the next step is to search out the appropriate oxides that might create these effects. This information can be found in Appendixes A and C.

Using appropriate oxides, make a glaze formula similar to those shown in this chapter, listing bases, neutrals and acids. The general range for these oxides at the desired temperature can be found in the Limit Formulas on page 173.

The next step is to lay out a chart similar to those used throughout the chapter and fill in the Oxides in Formula and Moles in Formula. Choose the appropriate materials and list them and their calculation formulas in the proper boxes in the chart. Do the necessary arithmetic to arrive at the moles needed. Show the answers in the chart. Then list the materials and their moles. Multiply

"Clay is a very forgiving medium. The texture is relaxing and soothing to the mind. Working with clay, the final product is totally up to me. Each piece reflects me and my life. Working on the wheel allows me to create simple functional objects of beauty."
Michelle Malo

each by their own Equivalent Weight to derive the Weight Factors. Do the arithmetic needed to arrive at a Percentage Batch Weight. (These steps are listed in the section "To Calculate from Glaze Formula to Percentage Batch" on page 174.)

Mix the materials according to these calculations. Prepare a sample tile and fire. First results are rarely perfection. Examine the tiles, suggest changes in the formula based on the information in the appendixes, and try again. If the glaze formulas have been well thought out, reasonable fired results should not be long in coming.

Glaze Recipes

For those who just want to mix a glaze and get on with it, Appendix D has recipes for clays and glazes in various temperature ranges.

Glaze Types

Of more general interest, this section describes a number of different glaze techniques with appropriate examples.

10 Firing

Teachers need to carefully read and reread the information in this chapter. Students, although they may not actually take part in firing a kiln, should also be required to learn all the material and fully understand it.

The best claywork with the finest designs and the most original colorations can end up as shards if care is not taken when firing the kiln.

Everything mentioned in the early portion of this chapter is essential to a good firing.

Heating and cooling cycles.
Proper kiln furniture and special equipment.
Kiln wash.
Pyrometers and pyrometric cones.
Keeping a kiln log.
Stacking a kiln.
Bisque firing.
Glaze firing.

Also discussed in this chapter are oxidation and reduction firing, local reduction, salt glazing, raku, wet firing, wood firing, primitive firing and crystalline glaze.

Depending upon your resources, primitive firing, raku and possibly local reduction firing can be fairly easily incorporated into a course as class projects.

Defects

Even if all of the procedures outlined in this text are followed to the letter, sometimes things do go wrong. Rather than pretend that this is not the case, possible problems are cited throughout the reading, and appropriate suggestions are given. In particular, the section on "Firing Defects" lists, explains and offers corrections to virtually any clay or glaze defect associated with firing.

Instead of just trashing a defective project, use the object as an example and ask the class to suggest ways to prevent the problem from recurring.

As discussed in the Spotlight, "From Accidents to Art," in some cases a supposed defect can actually become a highly desired effect. A particularly intricate example is the double crackle glaze first developed in the Orient many years ago. A crackle glaze is really a crazed glaze that has been controlled. In the example, the potter first fired the work to a temperature that caused the glaze to craze on cooling. Iron oxide was rubbed into the cracks. The piece was refired to a slightly different temperature, causing new cracks to form. These were rubbed with cobalt oxide. The piece was then refired to the correct temperature, smoothing out the glaze. The final effect is a porcelain jar coated in a pale green celadon glaze encircled with a web of deep red and blue lines.

11 Kilns, Wheels and Studio Equipment

As the name implies, this chapter discusses equipment necessary to the ceramic process, including a historic overview of kilns from primitive on-ground fires to the latest solar- and laser-fired methods.

Various types of wheels in use around the world are mentioned and pictured.

A check list of equipment and supplies is included to assist in the smooth running of a ceramic studio.

The Spotlight shows how to build a heat efficient kiln from a surplus 55-gallon drum.

12 Plaster

Plaster can be boon or bane of the ceramic studio. Improperly handled, errant plaster chips can reduce the finest claywork to shards during a firing.

Carefully controlled, plaster can be used to make drying bats, press molds and two-piece molds for slipcasting. The proper methods are explained in this chapter.

13 Slipcasting

Slipcasting is a method of producing ceramic objects entirely different from the techniques used in handforming. It requires a different studio setup as well as a particular type of clay manufactured specifically for the process.

The information is included here for those who wish to learn about commercial production methods.

14 Marketing

The first question students often ask a visiting clay artist is, "Can you make a living at pottery?"

This chapter offers suggestions about pricing, consignment versus outright sales, fairs and trade shows and other aspects of marketing. If these notes are followed carefully, the answer to the number one question can be a positive one.

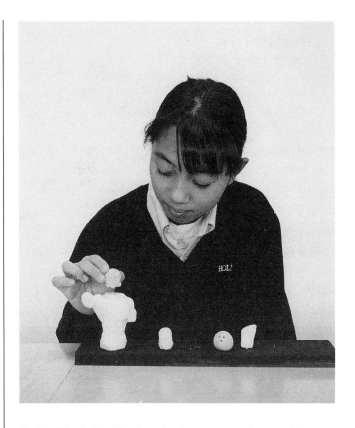

Senior Nicole Pupillo showing her anatomy figure with interchangeable heads. "I plan to become a medical illustrator, so I'm interested in learning the correct proportions of the human body. But in order to make my study more interesting, I made different heads for the figure—an ape head, a regular head, a bowling ball and Gumby. It's serious and fun at the same time."

Conclusion

This text is filled with the latest facts and information about clay and glazes. It is profusely illustrated with hundreds of how-to pictures, historical and contemporary examples — in black-and-white and color. It has tips, ideas, secrets, and projects never before collected into one volume. But with all of this, one thing is still missing. Life.

The pages have no life of their own. It is up to you as the teacher to make this information come alive. Think of this text as a road map with all of the points of interest neatly laid out and highlighted. With careful planning, motivation and an eagerness to explore, you can guide your class through an exciting and enriching adventure into the world of ceramics — a trip that they and *you* will enjoy.

Annotated Selected Bibliography

Methods

Ball, F. Carlton and Janet Lovoos. *Making Pottery Without a Wheel.* New York: Van Nostrand Reinhold Company, 1965, 159 p. illus.
Basic handbuilding methods demonstrated with simple project ideas for beginners.

Berensohn, Paulus. *Finding One's Way With Clay: Pinched Pottery and the Color of Clay.* New York: Fireside Books, 1987, 162 p. illus.
As stated in the title, an excellent source for ideas and information about pinch forming and colored clays.

Kenny, John B. *Ceramic Design.* Radnor, PA: Chilton Company, 1963, 322 p. illus.
Dated but informative volume covering sculptural aspects of working clay by handbuilding, wheel and slipcasting methods.

Nigrosh, Leon I. *Low Fire: Other Ways to Work in Clay.* Worcester, MA: Davis Publications, Inc., 1980, 102 p. illus.
Discusses low-temperature decorating and firing methods from primitive fire to modern photoclay techniques.

————. *Sculpting Clay.* Worcester, MA: Davis Publications, Inc., 1992, 182 p. illus.
A companion text to Claywork *that discusses in detail all aspects of ceramic sculpture from ideas and principles through forming methods to heads and figures, plaster, firing and gaining commissions.*

Materials Information

Grebanier, Joseph. *Chinese Stoneware Glazes.* New York: Watson-Guptill Publications, 1975, 144 p. illus.
Thorough coverage of early Chinese reduction glazes with formulas recalculated for current materials.

Green, David. *Pottery Glazes.* New York: Watson-Guptill Publications, 1973, 144 p. illus.
Good source for chemical and geological background information about glazes. Discusses preparation of materials and correcting faults in glazes.

Rhodes, Daniel. *Clay and Glazes for the Potter.* Revised edition. Radnor, PA: Chilton Book Company, 1973, 330 p. illus.
Important reference for technical information regarding clays, glaze materials and glaze formulation.

Toxicology

Barazani, Gail. *Ceramics Health Hazards: Occupational Safety and Health for Artists and Craftsmen.* Revised. Boscobel, WI: Art-Safe, Inc., 1984, 20 p.
Discusses safe studio practices. Lists ceramic materials, their possible hazards and suggests cautionary controls.

Qualley, Charles. *Safety in the Artroom.* Worcester, MA: Davis Publications, Inc., 1986, 120 p.
Discusses hazards found in the artroom as well as precautionary measures to be taken. Also discusses legal issues concerning artroom safety.

Seeger, Nancy. *A Ceramist's Guide to the Safe Use of Materials.* Chicago: The Art Institute of Chicago, 1982, 44 p.
Lists ceramic materials, discusses hazards and gives specific precautions.

Kiln Construction

Fraser, Harry. *Electric Kilns.* New York: Watson-Guptill Publications, 1974, 144 p. illus.
"A detailed guide to buying, building and firing electric kilns." Discusses design, construction, repair and firing,

and describes automatic temperature controls and their proper use. Not overly technical.

Olsen, Fredrick L. *The Kiln Book*. 2nd edition. Radnor, PA: Chilton Book Company, 1983, 292 p. illus.
Complete, easy-to-understand, discussion of many types of kiln designs, materials and methods of construction. Explains advantages and disadvantages of various fuels: wood, coal, gas, oil, electricity.

Design and Philosophy

Grillo, Paul Jaques, *Form, Function and Design*. New York: Dover Publications, Inc., 1975, 238 p. illus.
General guide to basic design principles. Discusses essential elements such as materials, proportion and scale along with intuitive aspects of composition, energy, motion and originality.

Leach, Bernard. *A Potter in Japan*. London: Faber and Faber, 1960, 246 p. illus.
Personal journal of his stay in Japan by one of the United Kingdom's most famous potters. Reveals his feelings and philosophy about Japan, its people and their pottery.

Rawson, Philip. *Ceramics*. Philadelphia: University of Pennsylvania, 1984, 224 p. illus.
Extensive discussion about the aesthetics of pottery. Well written foundation for critical appreciation of contemporary ceramics.
Roukes, Nicholas. *Art Synectics*. Worcester, MA: Davis Publications, Inc., 1984, 156 p. illus.
Exciting resource to help encourage creative thinking. While not a ceramic text, many of the activities easily adapt to claywork.

Schuman, Jo Miles. *Art From Many Hands*. Worcester, MA: Davis Publications, Inc., 1981, 251 p. illus.
Diverse exploration of arts and crafts with a multicultural approach. Step-by-step projects in diverse mediums include clay and mosaic tile.

Historical and Contemporary Ceramics

Charlston, Robert J., ed. *World Ceramics*. Secaucus, NJ: Chartwell Books Inc., 1976, 352 p. illus.

Profusely illustrated overview of ceramics from prehistory to the present. Covers major influences and movements worldwide.

Clark, Garth. *American Ceramics: 1876 to the Present*. Revised. New York: Abbeville Press, 1987, 351 p. illus.
Lavish overview of major contributions to American ceramic "tradition" including an extensive list of biographies of important figures.

Levin, Elaine. *The History of American Ceramics: 1607 to the Present from Pikkpkins and Bean Pots to Contemporary Forms*. New York: Abrams, 1988.
Expansive overview of ceramic development in the United State arranged chronologically. Numerous large, colorful images of important works illustrate the various periods and movements discussed.

Speight, Charlotte F. *Images in Clay Sculpture*. New York: Harper & Row, 1983, 216 p. illus.
Survey of historical and contemporary clay sculpture. Includes forming methods as well as interviews with contemporary clayworkers.

Slides, Video and Film

Creative Computer Visions (CCV)
Box 6724
Charleston, WV 25362-0724
multimedia catalog, CD-ROM, video laser discs

Crystal Productions
Box 2159
Glenview, IL 60025
videos, multicultural art prints, laser discs

Media for the Arts
Box 1011/360 Thames Street
Newport, RI 02840
slides, video, laser discs

Universal Color Slide Co.
8450 South Tamiami Trail
Sarasota, FL 34238-2936
individual slides of historical and contemporary ceramics

Correlations to Essential Elements and TAAS

CONTENTS	PAGES	ESSENTIAL ELEMENTS	TAAS
Chapter 1: Clay	12–16, 18, 19	1A, 2B	
	12–14, 16	1B	
	16	1C	
	15, 16, 18, 19	2A	
	12, 14, 15	3A, 3B, 4A, 4B	
	13–16, 18, 19	---	R1, R2, R3, R4, R5, R6
	Spotlight: 17	1A, 1B, 1C, 2B, 3A, 3B	R1, R3, R4, R5, R6
Chapter 2: Pinch	20–27	1A, 1B, 1C, 2B, 3A	R1
	21, 22, 24–26	2A	
	20, 22–27	3B, 4A, 4B	
	21–26	---	R2, R3, R4, R5, R6
Chapter 3: Coil Building	28–31, 34–39	1A, 2B	R1, R3, R6
	28–31, 34–36, 39	1B, 1C, 3A, 3B, 4A, 4B	
	30, 31, 37–39	2A	R2, R4, R5
	Spotlight: 32, 33	1A, 1B, 1C, 2B, 3A, 3B, 4A, 4B	R1, R2, R3, R4, R5, R6
Chapter 4: Slab Construction	40–63, 66–71	1A, 2B	R1, R3, R6
	40, 42–51, 53–63, 66–71	1B, 1C	
	41, 42, 45–48, 50, 52–54, 56, 59, 61, 66, 67, 69	2A	R2, R4, R5
	40, 43–51, 53–63, 66–71	3A, 3B, 4A, 4B	
	Spotlight: 64, 65	1A, 1B, 1C, 2B, 3A, 3B, 4A, 4B	R1, R3, R5, R6
Chapter 5: Throwing	72–84, 86–111	1A, 2B	R1, R3, R6
	72, 78, 82–84, 89, 91–102, 104, 106–111	1B	
	72, 82–84, 89, 91–102, 106–111	1C	
	73–80, 82–84, 86–93, 95–99, 103–105, 107–111	2A	R2, R4, R5
	72, 82–84, 89, 92, 94–97, 99–102,104, 106–111	3A, 3B, 4A, 4B	
	Spotlight: 85	3C	
Chapter 6: Design in Clay	112–117, 120, 121	1A, 1B, 1C, 2B	R1, R2, R3, R6
	112–116, 121	3A, 3B, 4A, 4B	
	114–116	---	R4, R5
	Spotlight: 118, 119	1A, 1B, 1C, 2B, 3A, 3B, 4A, 4B	R1, R3, R4, R5, R6